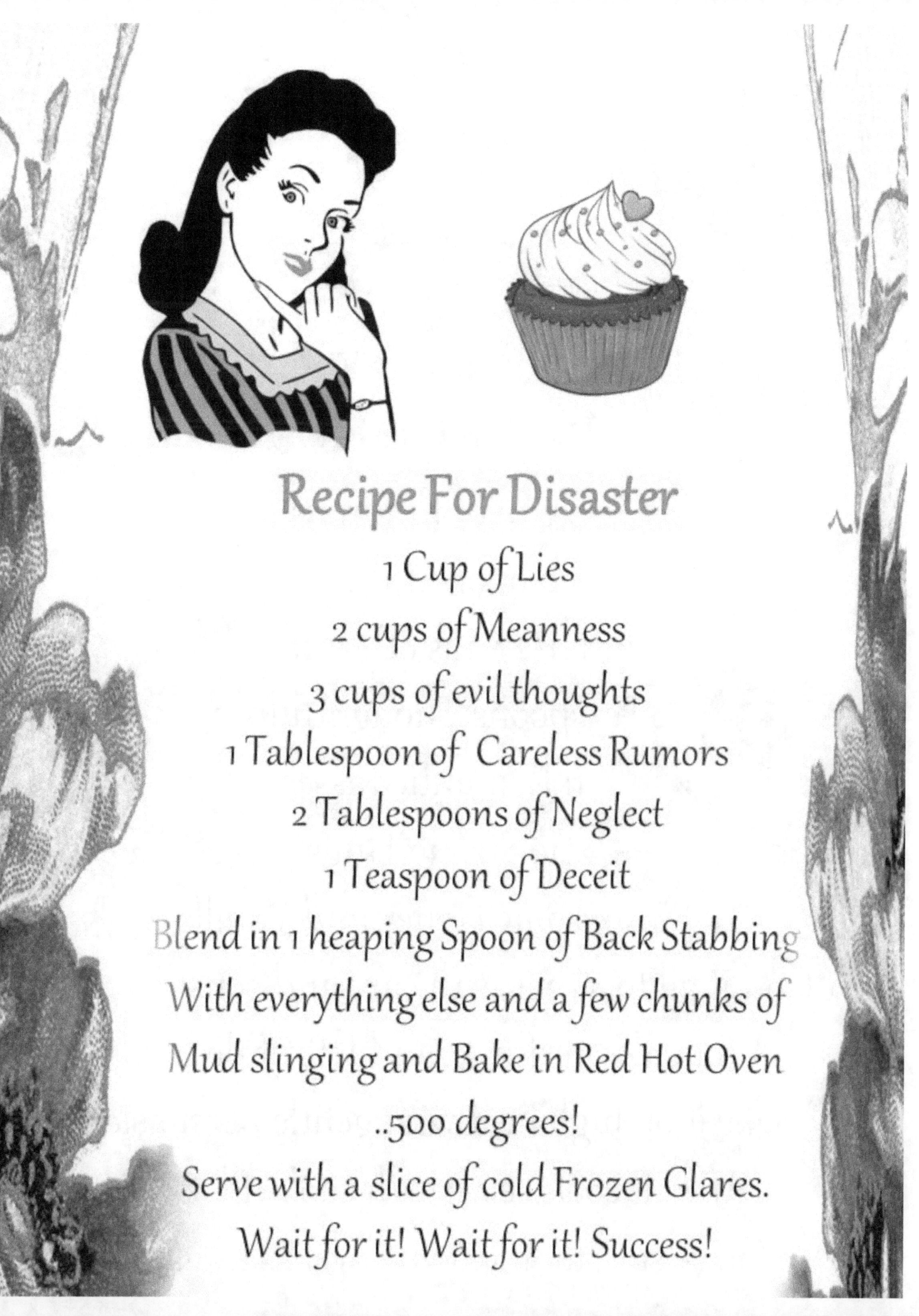

Recipe For Disaster

1 Cup of Lies

2 cups of Meanness

3 cups of evil thoughts

1 Tablespoon of Careless Rumors

2 Tablespoons of Neglect

1 Teaspoon of Deceit

Blend in 1 heaping Spoon of Back Stabbing
With everything else and a few chunks of
Mud slinging and Bake in Red Hot Oven
..500 degrees!
Serve with a slice of cold Frozen Glares.
Wait for it! Wait for it! Success!

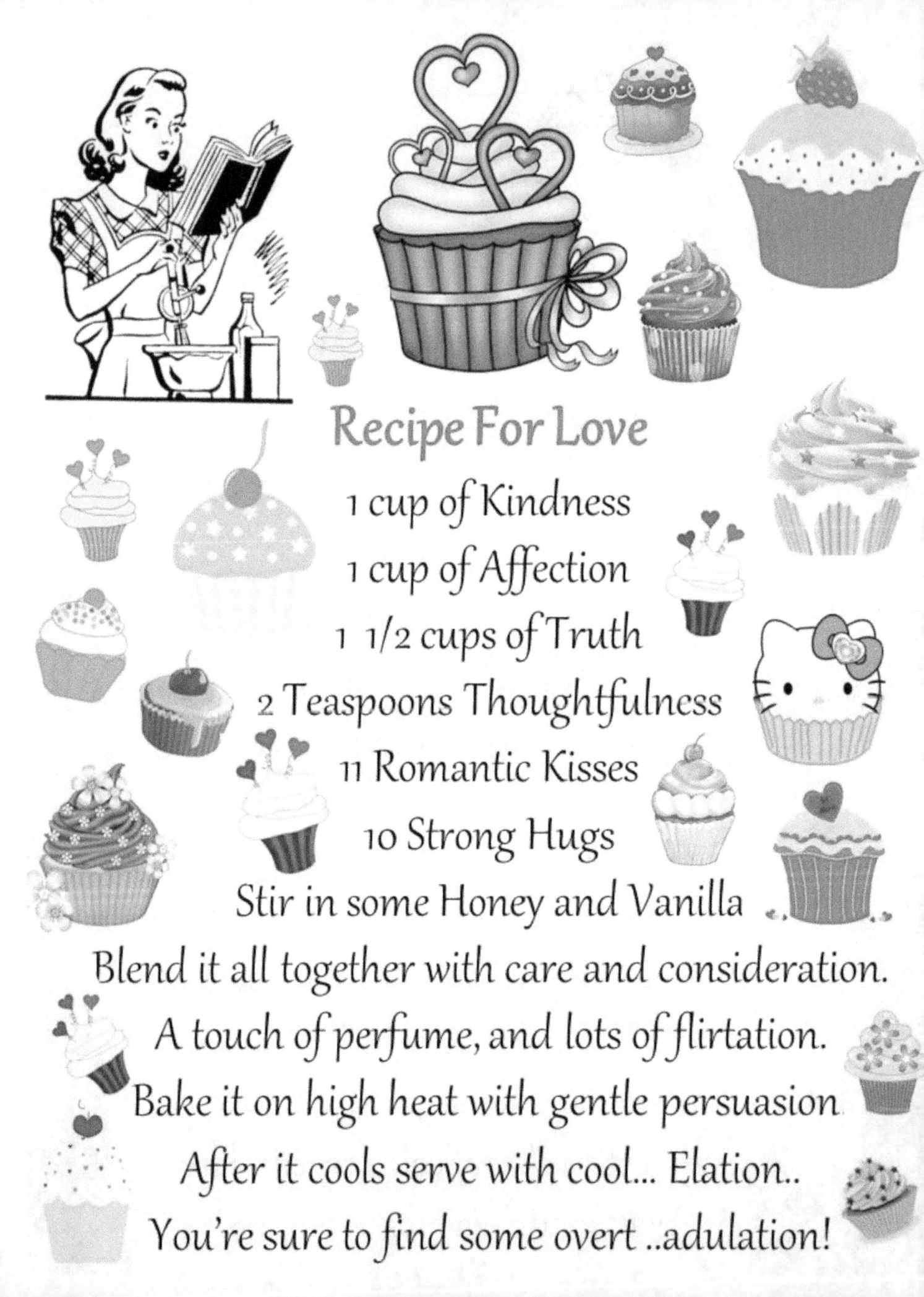

Recipe For Love

1 cup of Kindness
1 cup of Affection
1 1/2 cups of Truth
2 Teaspoons Thoughtfulness
11 Romantic Kisses
10 Strong Hugs
Stir in some Honey and Vanilla
Blend it all together with care and consideration.
A touch of perfume, and lots of flirtation.
Bake it on high heat with gentle persuasion.
After it cools serve with cool... Elation..
You're sure to find some overt ..adulation!

Dolly dear Dolly, please listen to me!
We have to share with each other, don't you see?
When Molly has a turn to play with us too..
You must be kind and fair in all that you do!

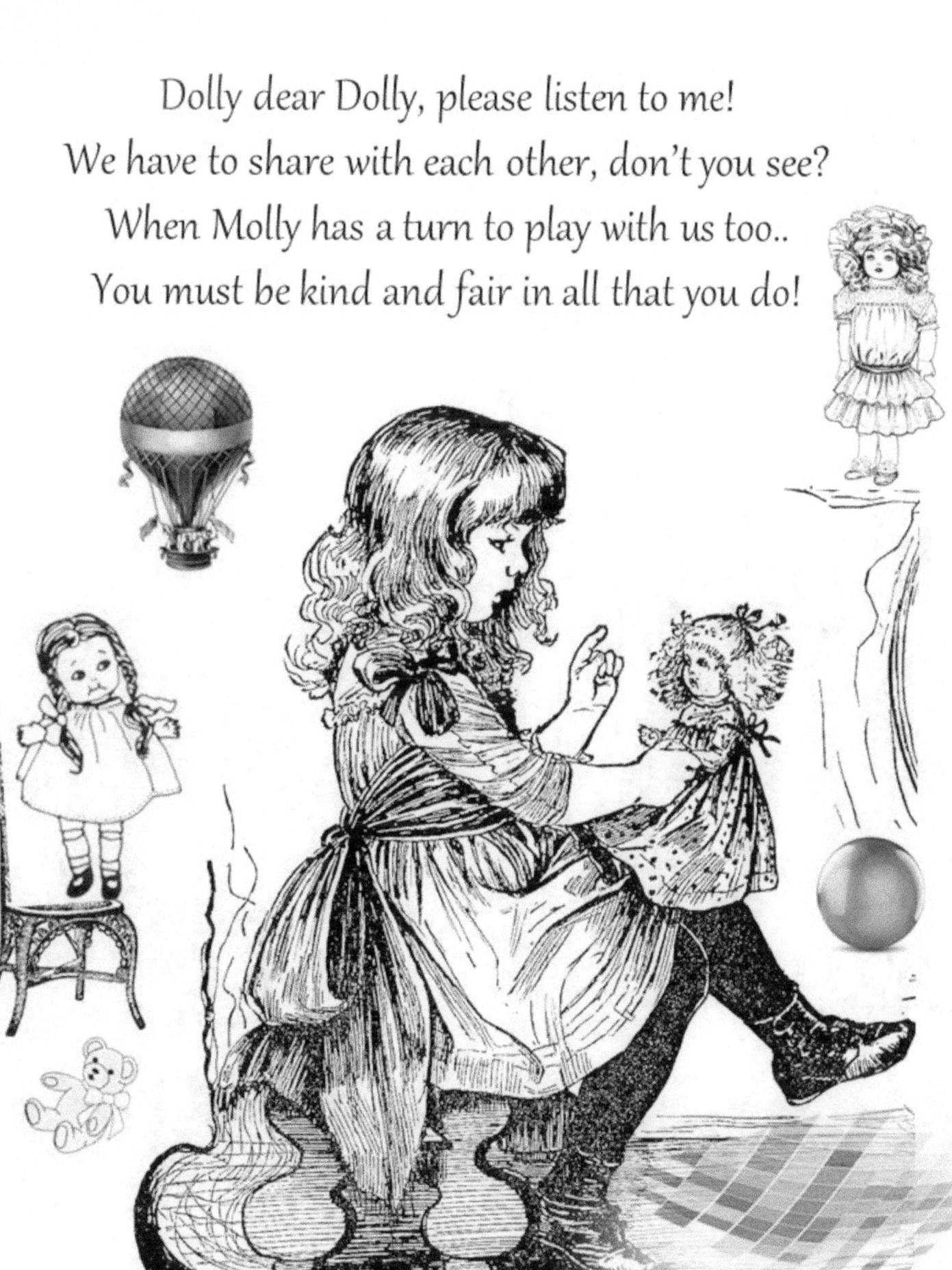

www.ingramcontent.com/pod-product-compliance
Lightning Source LLC
Chambersburg PA
CBHW080529190526
45169CB00008B/3110